How to Draw Your

Dragon

Drawing Your Favorite Cartoon Dragons
Step by Step Guide

By Jessica McKenzie

Copyright©2016 by Jessica McKenzie

Table of Contents

Disclaimer

While all attempts have been made to verify the information provided in this book, the author does assume any responsibility for errors, omissions, or contrary interpretations of the subject matter contained within. The information provided in this book is for educational and entertainment purposes only. The reader is responsible for his or her own actions and the author does not accept any responsibilities for any liabilities or damages, real or perceived, resulting from the use of this information.

The trademarks that are used are without any consent, and the publication of the trademark is without permission or backing by the trademark owner. All trademarks and brands within this book are for clarifying purposes only and are the owned by the owners themselves, not affiliated with this document.

Introduction

If your favorite fantasy movie is How to Train Your Dragon, you surely would like to learn how to draw a character from the film. Luckily for you, in this book, there is everything you need to know about drawing a funny dragon picture.

How to Train Your Dragon is a 2010 animated 3D film, which was loosely based on a book series by the British author, Cressida Cowell. Both book and the movie were immediately popular and dragon characters like Toothless, for example, became favorites of many children across the world.

The movie was met with quite a lot of success, earning a total of $500 million, worldwide, which is a huge amount having in mind that the production of How to Train Your Dragon cost more than three times less.

The story is about a Viking child, called Hiccup, who is about to become a dragon slayer, same as all of the members of his family. However, in his heart, Hiccup doesn't want to become that. After capturing his first dragon, Hiccup decides to leave him life and the two become friends.

The dragon's name was Toothless, given by Hiccup for dragon's ability to retract his teeth. Hiccup helps the dragon on several occasions, allowing the dragon to fly. His training makes Hiccup to realize that dragons and people can be friends.

Apart from Toothless, whom children find very interesting, there are a few more dragon characters in the movie, all of which look great when put on the paper. In this book, you will also learn how to draw Red Death, the main villain in the film. Red Death is a giant dragon, who is evil and feeds on smaller dragons. Because of his strength, Red Death threatens younger and smaller dragons that he will eat them unless they bring him livestock.

Apart from amazing animation, How to Train Your Dragon is also famed for amazing voice acting. The production included hiring some of

the most famous comedy actors in the world. Jonah Hill, the star of 21 Jump Street and a number of other hilarious comedy movies, gave the voice to Snotlout Jorgenson, one of Hiccup's friends and a student of dragon slaying.

Speaking of Hiccup, he is voiced by Jay Baruchel, a Canadian comedian, known for a number of roles in many TV series. Craig Ferguson, a famous TV host, gave his voice to Gobber the Belch, the blacksmith and the teacher in the dragon slaying school. Hiccup's father, Stoick the Vast was voiced by Gerard Butler.

All of the characters in the movie How to Train Your Dragon are interesting and great for drawing. Still, dragons are the most interesting for putting them on the paper, which is what is described in the step by step guide in this drawing book. So, keep on reading and you'll find out how to draw Toothless and other dragons!

Chapter 1 - Boost Your Child's Creativity Through Drawings

Very often, we find ourselves under pressure of great desire for our child to be successful, progressive, competent, satisfied... We want to assess whether there is something that we as parents need to give, give, allow, etc.

Because children are not "burdened" with that - because they are not cognitively able to clearly express their needs. Usually all they want, what they are aware of, and demand is play. But, we can try to figure out the child's inner world through a variety of indirect methods. One of these methods is drawing!

The development of children's drawing abilities can provide a lot of information on the development and needs of the child.. Some intelligence tests are based on the image drawing, ie. drawing the human figure, whose assessment tells us about the intellectual abilities of the child.

Tendency for drawing or painting at an early age can be indicator of how much the child is talented. But this is only a small part of the overall artistic talent.

Some of specific skills that affect the appearance of the child's drawings -Intelligence is one of those skills. In addition to intelligence there definitely are some artistic skills, resources and preferences.

When working with children drawing can serve in two ways:

- As a form of diagnosis - the drawing can serve as a sort of estimate of the child's abilities, emotional and social skills...

- As a form of therapy - trauma, grief, fear and a number of other emotions can be can be expressed through drawing.

However, therapeutically properties are not the only thing that drawing gives to children. It also boosts creativity.

Creativity can be defined as the joining of things in new ways of seeing the world in a different way or a different view of the problem. We all need the creativity to solve everyday problems in life. Everyone is creative in some way, but you need to constantly boost your creativity in order to see its benefits. Drawing any kind of drawings is a great way for that. When it comes to kids, teaching them to draw their favorite movie characters is perhaps the ideal way to awake their creativity!

You cannot give your child talent, but you can help them to train their eye, ear and the way of thinking. You can help your child to develop concentration, competence, perseverance and optimism necessary for the development of creativity.

Earlier studies have started from the assumption that those children that were labeled by the art teachers as the "artistic types" were unusual and disorganized children who perform poorly in other areas. They were not right!

Teachers pointed out those students have had excellent results in other areas. Such children showed concentration in demonstration techniques, competence in planning their projects, etc.

Another feature was their optimism shown in the fact that they were more open to risking by choosing original ideas instead of proven techniques. Finally, those children showed a lot of determination – they were ready for investing more time in order to bring the project to the end. A few tips for developing creativity in children:

Neatness is overrated

Whether a child is afraid to get their hands dirty, does not like to leave your stuff in a visible and easily accessible place, or the child lives in accordance with many rules and does not think past them - too neat children are ranked as less creative.

Children who often have experience with limitations learn to think only within those limits!

The child needs to learn that some things are not allowed for security reasons, (such as not to allow them to touch the oven), but on the other hand, it should allow your child to see the world as something with a lot of options.

Focus on the game rather than on productivity

When children want to draw something to receive the praise from adults, it can happen that sometimes they do not finish all drawing to an end. Apparently, it's not about how many drawings they drew, but how much they became involved with that. If you praise them for the efforts invested in the drawing, the kids will not have to hurry to start a new drawing to get your approval.

Allow the child to be different

Witty, original children are often viewed differently from other children. Tell your child know it's okay to be different from their peers,

to be unique, and to see the world with different eyes. To develop the individuality of the child you need to support them to the fullest.

Make the child fall in love with the art

If your child wants to engage in creative art then it is likely that will create something interesting, which is why you must allow them to do it. It is of utmost importance for you to let your child be creative if they want to. But, that usually is not enough. You need to invest your time and your own creativity into this process.

A great way to make your child fall in love with creative art is to teach them to draw their favorite TV and movie characters. Luckily for you, you have a great ally here – this book will make this job very easy for you. It shows you how to draw dragons from the animated movie How to Train Your Dragon, the skills which you can teach to your kid and enable them to be creative as much as they can.

Not only will this interests you kid for drawing and open the doors for the infinitive universe of creative art, it will also provide them with fun. Drawing is one of the favorite hobbies, both for children and adults. Spending time drawing favorite characters is way better way than watching telly or playing violent computer games.

Join your child and learn how to draw favorite cartoon characters

Drawing dragon characters from the movie How to Train Your Dragon is not exclusive for children only. Grown-ups can and should learn to draw these cute characters, if for nothing else, then just because it looks awesome.

However, learning how to draw Toothless and the other dragons can be a great way to boost your creativity and learn how to draw similar objects. Once you learn how to draw dragons, you will find it easier to draw other mythological creatures, which are similar to dragons. In fact, you can unleash your creative mind and come up with your own mythical beast.

On top of that, you will also learn all the moves that are needed to draw animals that look a bit like mythical dragons. For example, reptiles and birds look very similar to dragons from this animated movie. Learning how to draw How to Train Your Dragon characters means you will learn how to draw dinosaurs as well.

Finally, learning how to draw dragon characters will make you fall in love with the movie if you didn't have time to watch it earlier. This is one of the most wonderful and inspiring stories, which earns it a place in the must-watch list.

Your Dragon 1–Baby Gronckle

Baby Gronckles are dragons with small wings, who can fly high and fast because of clapping them at fast pace. They're like hummingbirds, although much bigger. These babies need a lot of sleep and get extremely annoyed when waken up. In this chapter, you will learn how to draw these cute mythological creatures.

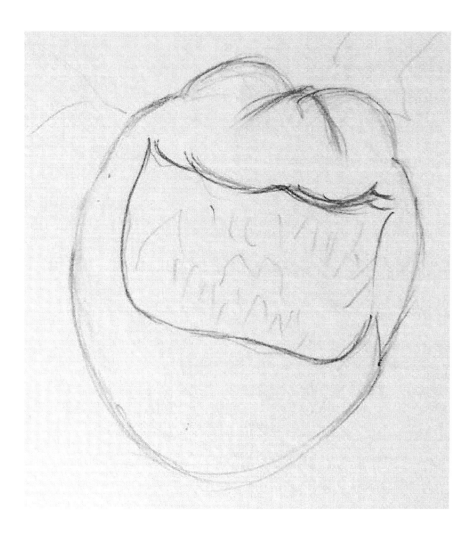

Start drawing your first dragon image by drawing a few simple objects. Create a basic image as your reference for dragon head. Also, add a few lines in order to draw dragon's teeth.

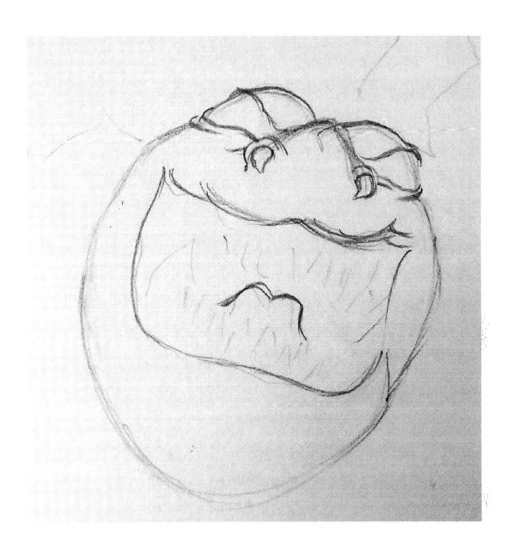

Add bold lines around head, mouth, nose and eyes of your dragon.

Make some definition lining around brows also.

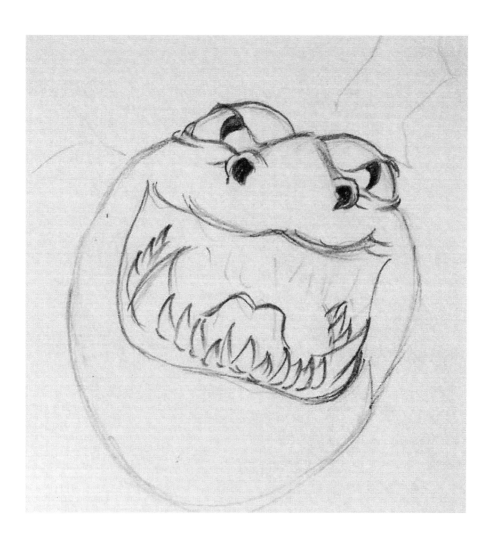

Finish with the dragon teeth. Now, shade nose holes and eyes.Make sure the teeth are nicely aligned.

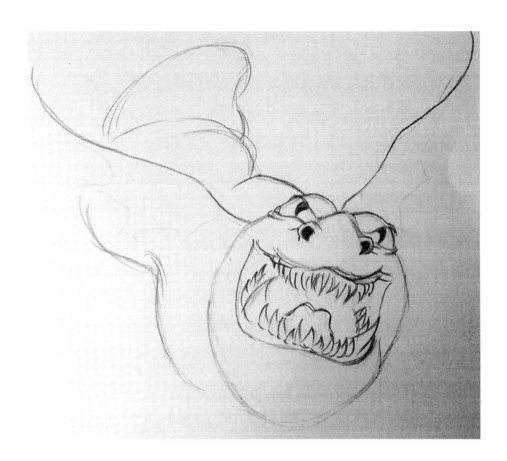

Draw a series of curved lines that connect the head and form the dragon's body. Also, add basic lines for dragon wings.

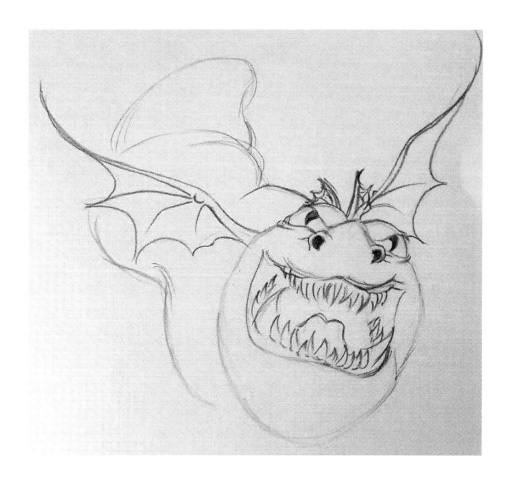

In this step, you are filling up dragon wings with series of curved lines inside. Make sure the wings are proportional to rest of the dragon's body you drew.

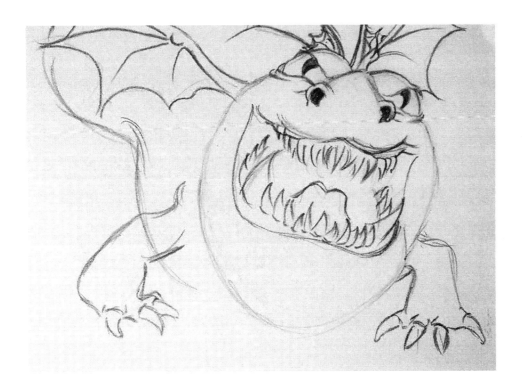

Up next, we are adding legs and claws. Again, make sure legs are proportional and well curved, so your dragon can be more realistic.

Now, you can add the last leg in the back which can be seen. Make sure the back leg has the same position as the front one.

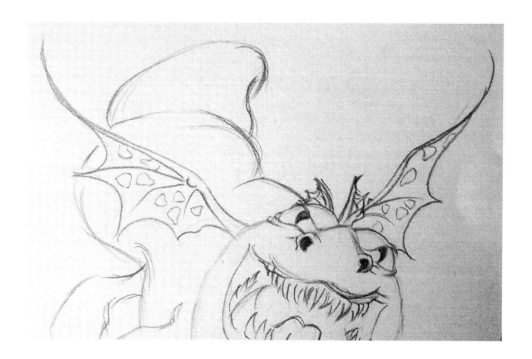

In this step, start adding details on dragon wings. These shapes must be nicely arranged, so there is not too much of them.

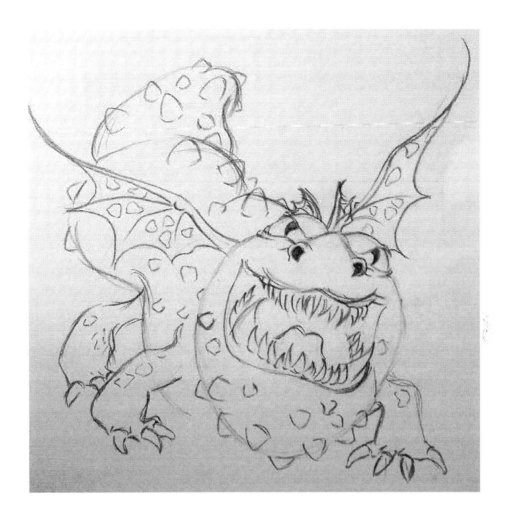

Now, you can add details on the dragon's body and spikes on his back and head. Again, try not to have too many details. The back spikes give your dragon more realistic look.

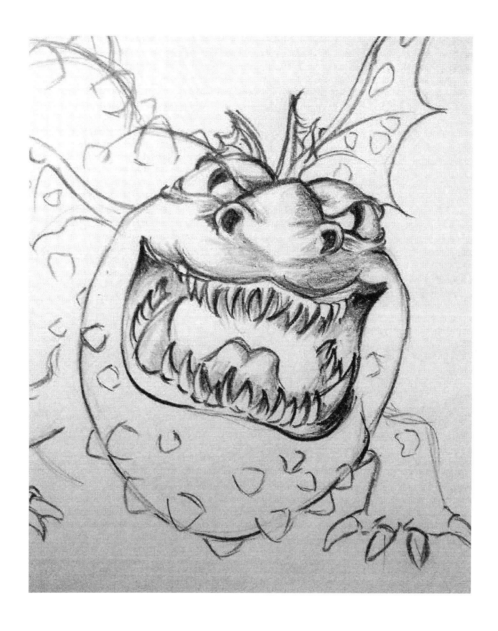

Finally, you can start shading the dragon starting off with the head. The shadings will give it more dimension and volume. Also, it gives mouth depth and dragon looks scarier.

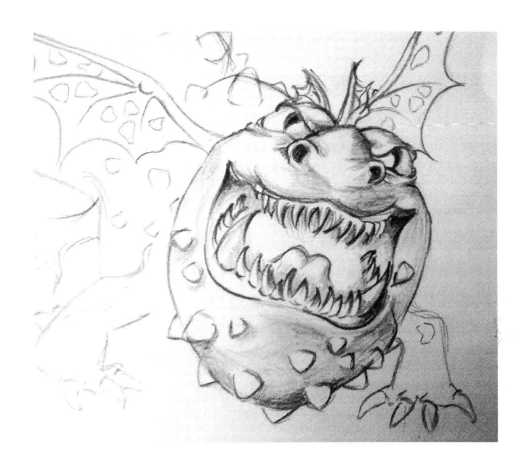

Finish head by shading bottom jaw. In this step, bold spikes on this part
of the head.

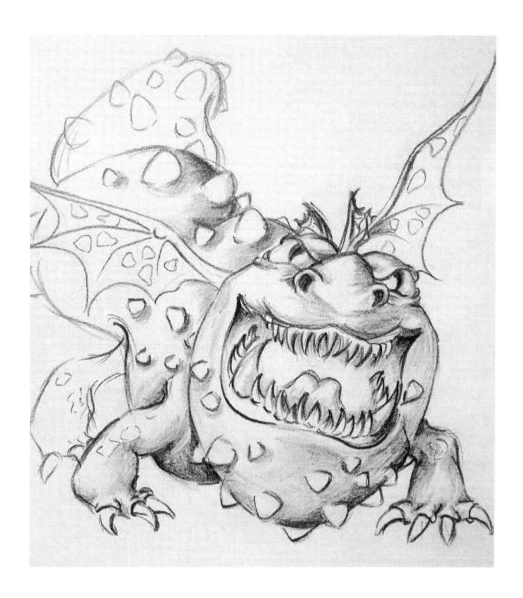

Now, start shading the front of the body. Try not to use too much darkens so you will not lose the main curves of your dragon.

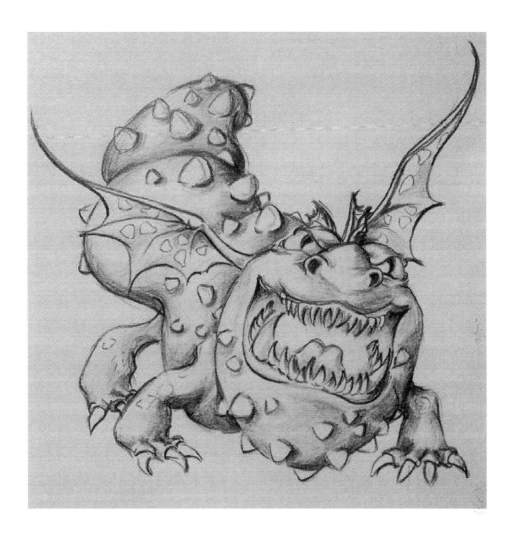

In the last step, shade the back, tail and wings of the dragon. Leave the details on wings unshaded because the contrast is also important since this is drawn with pencil.

Your Dragon 2–Toothless (Night Fury)

Toothless is the main dragon character in the movie. He's the one that the protagonist meets and spares. His ability to detract his teeth earned this dragon the nickname Toothless.

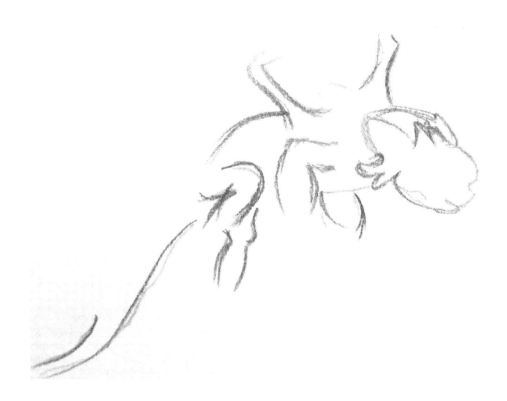

First, start drawing a shape of the dragon body. This is starting point and lines must be well curved since this is the main structure of the dragon.

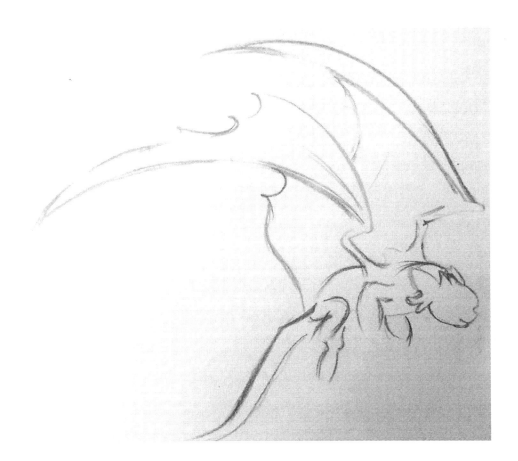

In this step draw dragon wings and connect the body curves. Also, finish up the dragon tail and bold top edges of the wings.

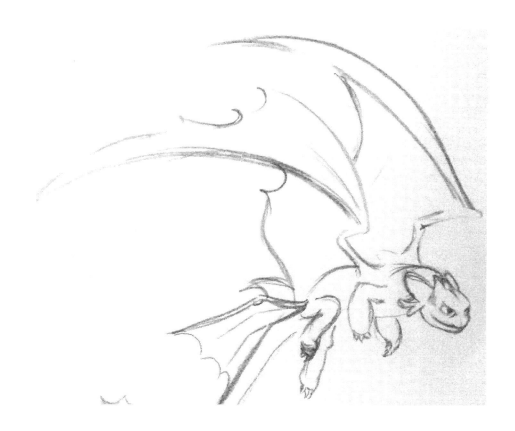

Now, close up the rest of the curves to form the legs and claws. Next add a small wing on the top of the tail and add some details on it. Add mouth curve and draw a circle for eyes of the dragon and shade them eventually.

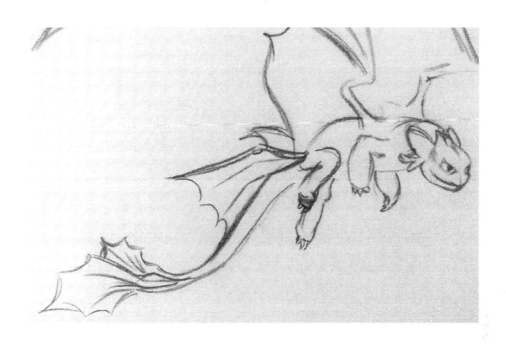

In this step focus the bottom part of the tail. Don't over think it. Just add lines randomly until you are satisfied.

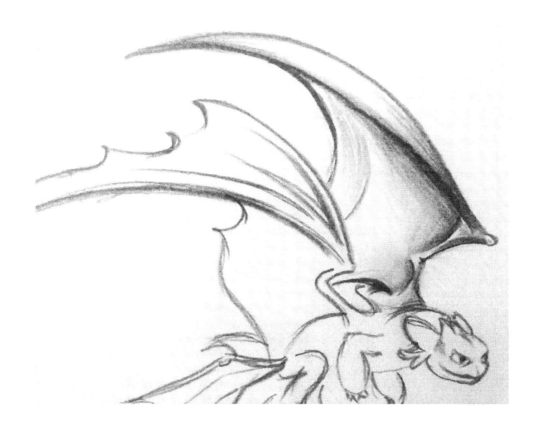

In this step you will start shading wings, starting up with the left one.

Vary the pressure on your pencil to get a different volume of shadings.

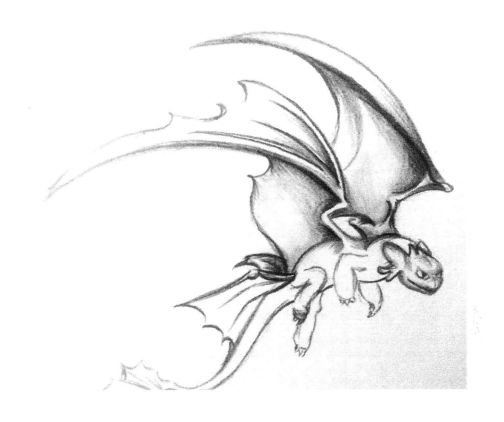

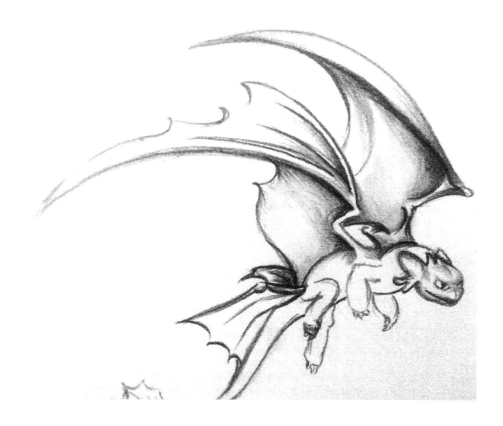

Then start shading the right wing and the head. Also, start shading the

back of the dragon. Pick the direction of the light source when shading

so that the shadows are consistent with it.

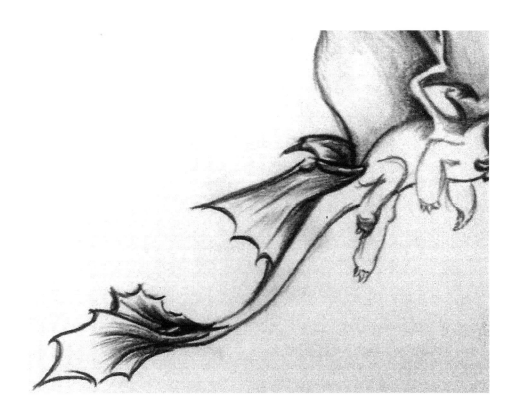

In this step finish shadings on the dragon tail. Bold curves so it will not lose the main structure, but still to have consistency in shadows.

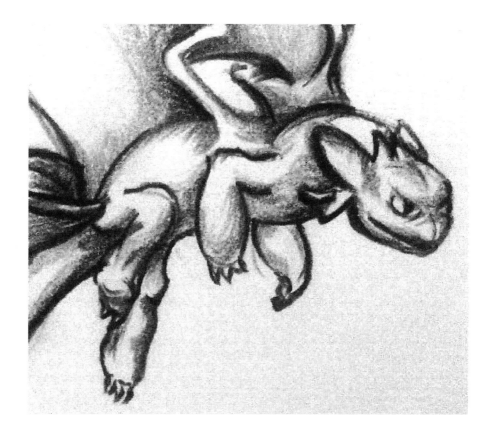

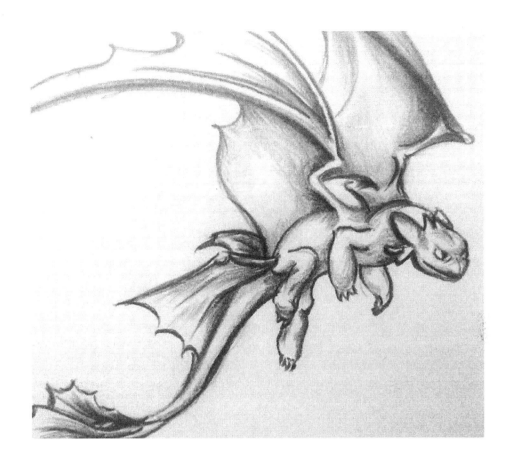

Now finish shading of the dragon with the bottom part of the body. Bold

leg curves and shades them properly.

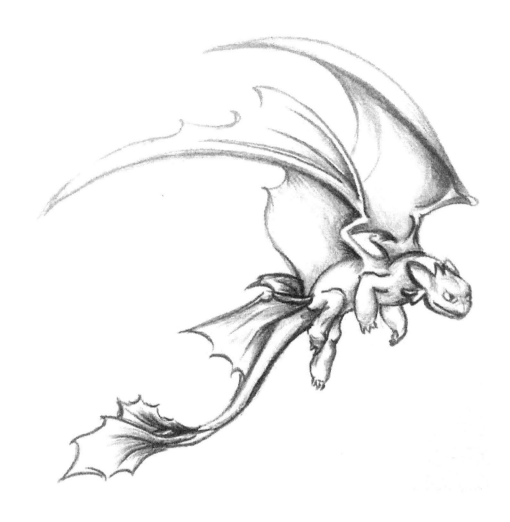

At the end, this is how your dragon should look like. Remember, dragons are mythical creatures so u can use your imagination and be creative.

Your Dragon 3—Terrible Terror

Although being small, this dragon is known as a huge troublemaker. He's made a lot of problems to the Vikings. In this chapter, you'll learn how to draw this small, but feisty being.

First of all, start drawing dragon' head. Draw a circle-like curve in the middle of the paper. The height of the circle will determine the dragon's neck length, so place it accordingly.

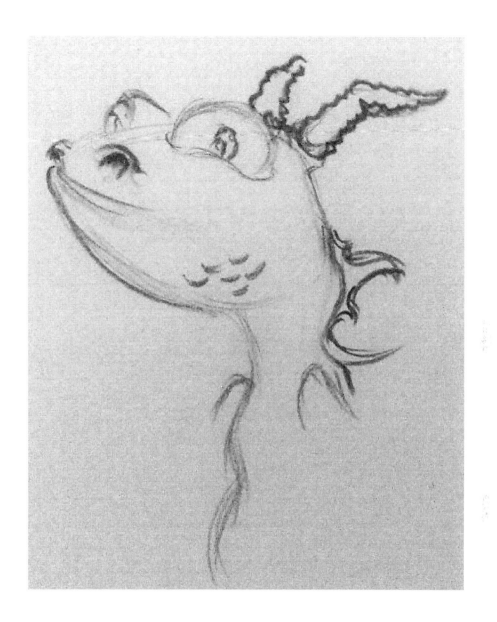

Now, start adding details on dragon's head. Draw the eyes and horns of the dragon. Try to bold the horns, and also add some spikes on the back side of the neck. Don't forget to add nose holes and shade them a bit.

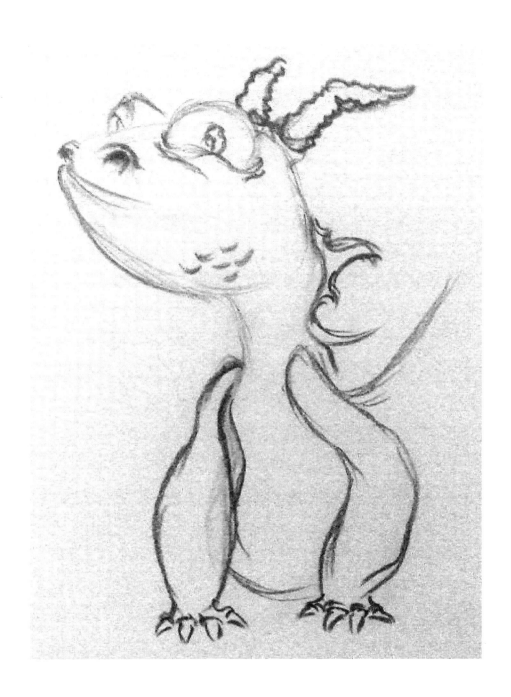

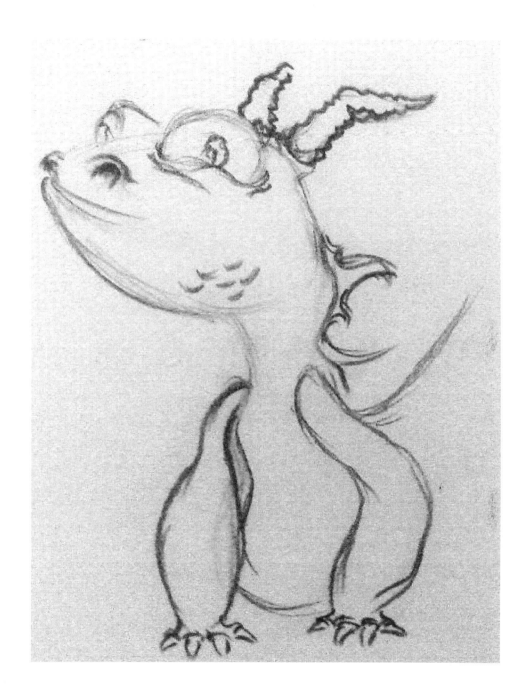

In this step focus the front legs of the dragon. Close up the neck curves

to for a body. Also, u can add a wing references.

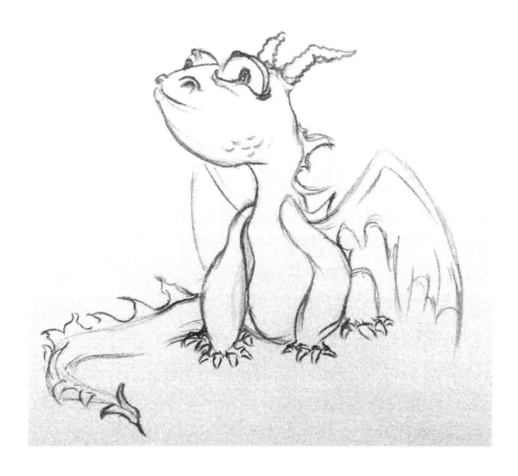

Next, draw a couple of lines that meet at a point on the left side to form a dragon's tail. The tail also has spikes on top of it, so be creative and use your imagination to draw them. Then add wings and back foot of the dragon.

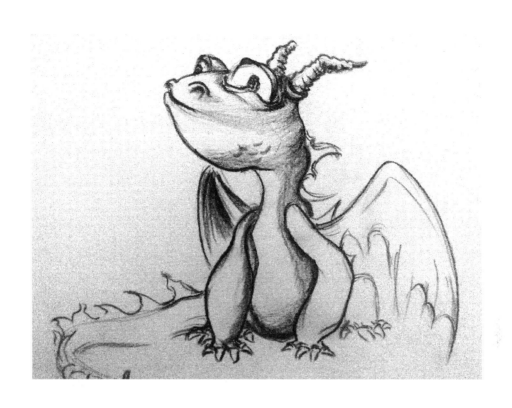

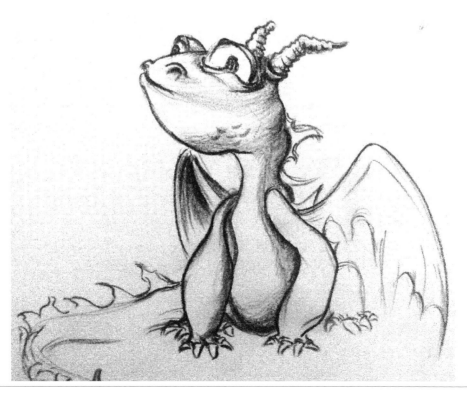

Now, you can start shading your dragon except his tail. Use darker at the bottom, since your dragon appears to be sitting. Also, bold curves around the dragon claws.

In this step, focus up shading the tail. The shadings are very rough. Just concentrate on defining the main outlines, shadows, and forms.

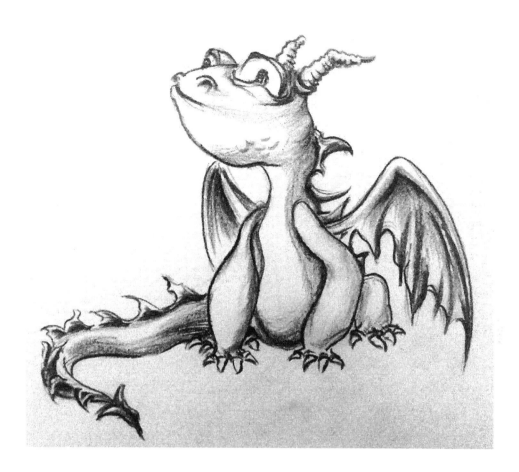

At the end, this is your dragon finished. Don't worry if u miss the curves when you're shading, since u can always use your rubber to erase some mistakes.

Your Dragon4–Toothless (Night Fury 2)

Night Fury is one of the fastest and definitely the most intelligent dragons in the movie franchise. These dragons are among the rarest. You can recognize them by their dark color and evil-looking eyes.

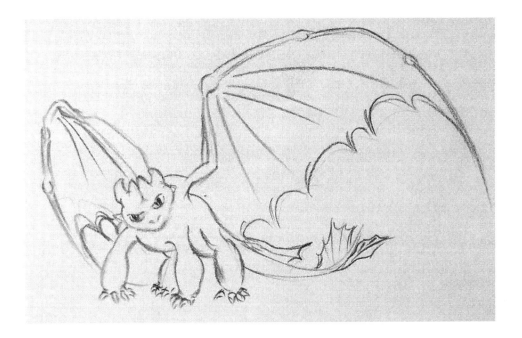

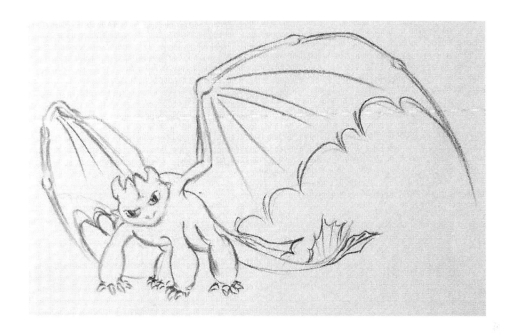

At the beginning, draw series of curves to form a dragon body. This is a little harder because we are drawing entire dragon at once.

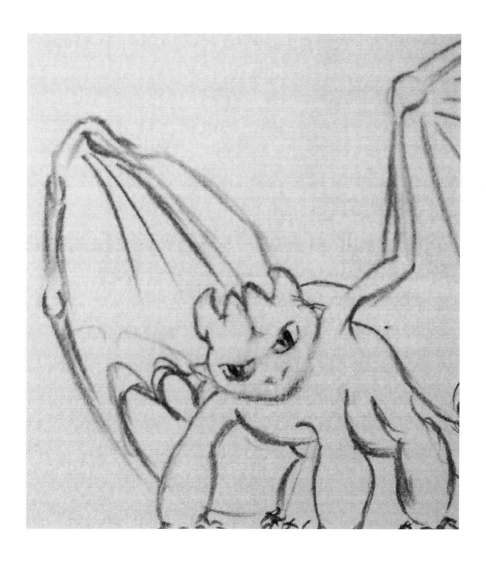

Draw wings so they look bony. Add some detailed curves inside them so they can appear as bent.

The left wing is bigger since it appears to be closer to you. Also, add some details on the tail. In this illustration, wings are really widespread.

In this step, you can start bold the edges of the dragon wings and prepare to shade them. You can use different pressure on the pencil for various bold levels.

Now, start shading the dragon's left wing. Don't go to rough on shadings because this is only beginning and u are making basics.

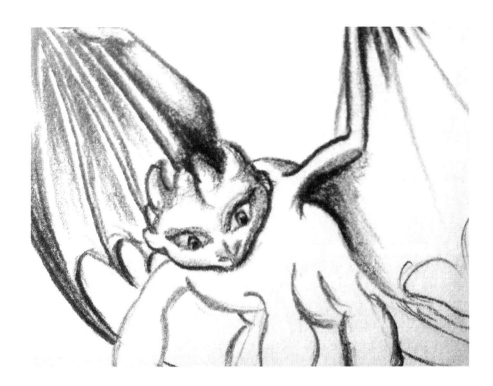

Now, you can shade dragon's right wing and some parts of the head. When you are shading wing, focus on picking the direction of light source.

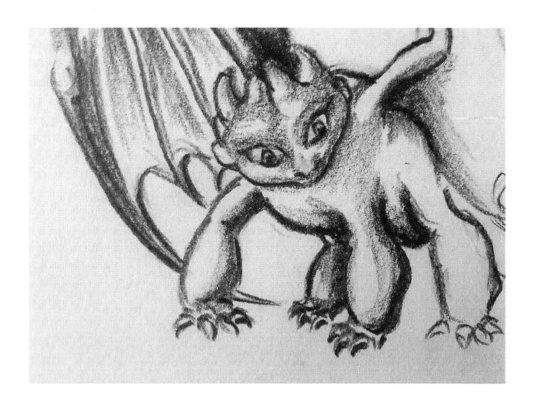

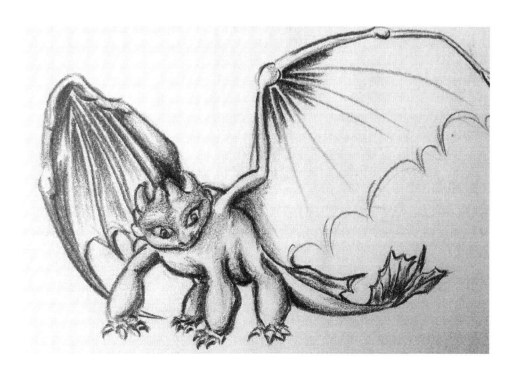

Now, start shading the body and the tail. If you want, u can add shadows underneath the dragon so it doesn't appear to be floating.

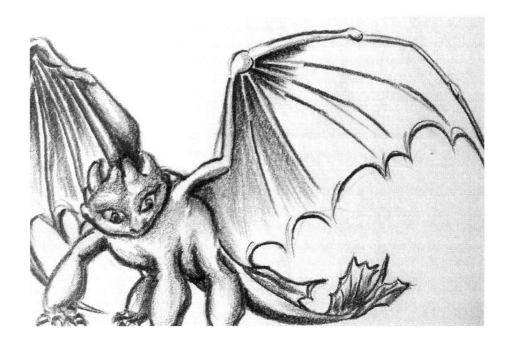

In this step, you can continue shading the left wing by dividing it into section based on details. Again, look at the light source and start shading properly.

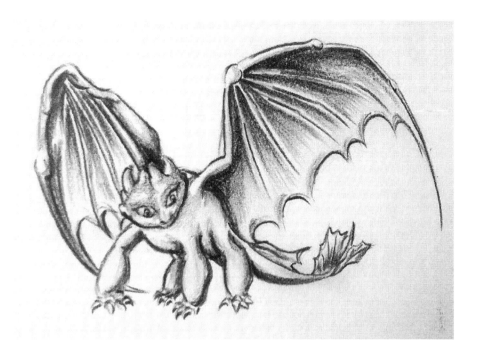

In the end, finish up shading the left wing and add some more details throughout your dragon drawing. Remember to widespread the dragon wings so it will appear bigger.

Your Dragon 5 – Stormfly

Stormfly is a female dragon, trained by Astrid. She has a large span of wings, which is why this dragon is great for her rider. Stormfly likes Hiccup very much and is loyal to Vikings.

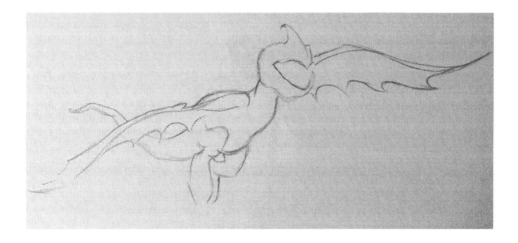

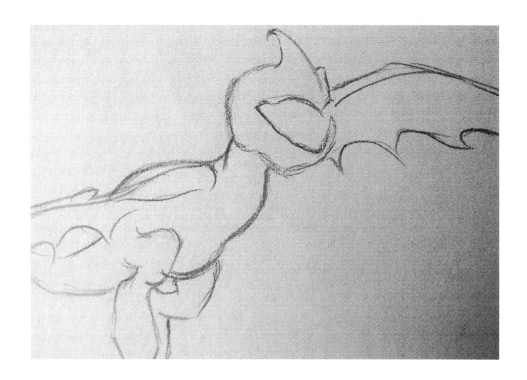

Start your drawing with series of curves to make dragon body. This dragon will be floating.

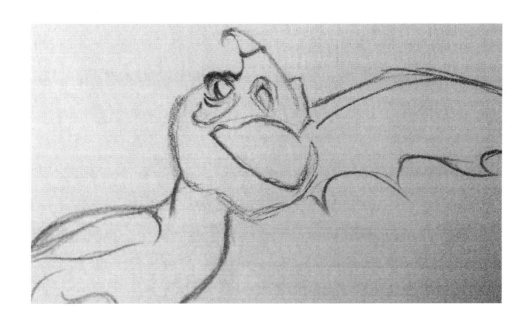

Now, start adding details on the head. Draw a circle and add eye and nose holes and shade them a bit.

In this step, bold mouth curves and adds teeth. The teeth look very sharp and unevenly. In this part, head is starting to get basic look.

Then add some spikes on the back of dragon head. The middle one is bigger than the others.

Now, you can shade that spikes in whatever way you want. Also, shade the eye of the dragon.

In this step, shade entire head of the dragon starting up from the top.
Then shade the inside of the mouth for more depth.

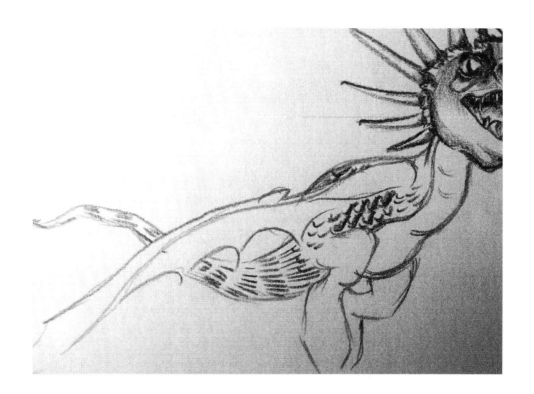

Now, add some details on the dragon body. Draw scales and rough leather-like skin.

Finish up dragon legs and start shading them. Also, draw claws, which are bent because your dragon is floating. Then add some shadows on the bottom of the tail.

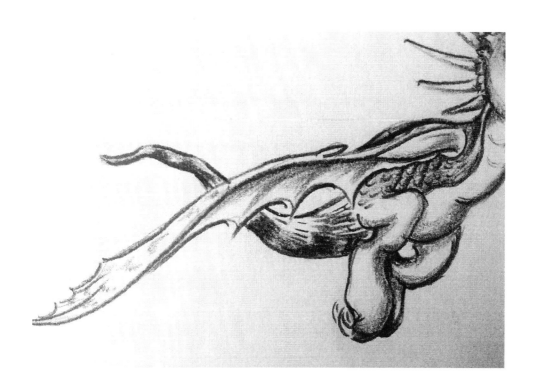

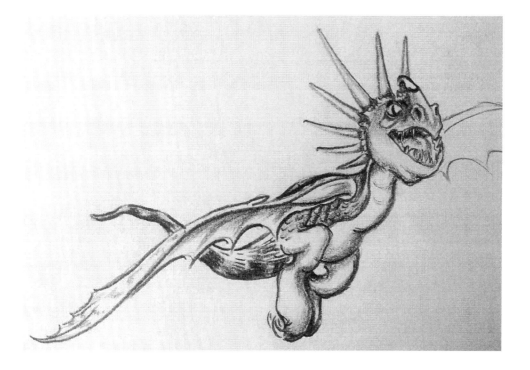

In this step, shadow the dragon's right wing. Make the edge of the wing sharp and rough. You can also add some more details if you want.

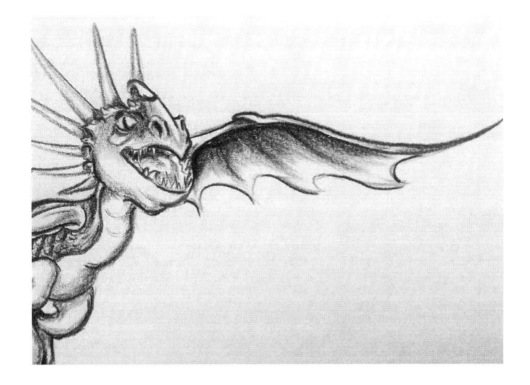

Then start shading dragon's left wing. The process is the same as with the right wing.

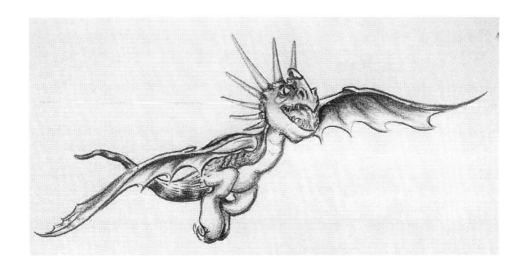

Finally, this is how your dragon should look like after finishing all steps above. Feel free to use your imagination and add as many details u want.

Your Dragon 6–Toothless (Night Fury 3)

Night Fury is a loyal companion to Hiccup. This dragon is fast, agile and smart. On top of that, he's very cute and you'll surely love drawing him.

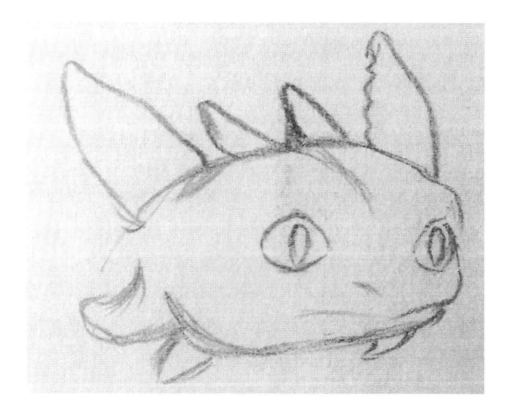

Start sketching your dragon by drawing a fish-like head. Draw two circles and add eyes. Also, draw a mouth curve, horns, and ears.

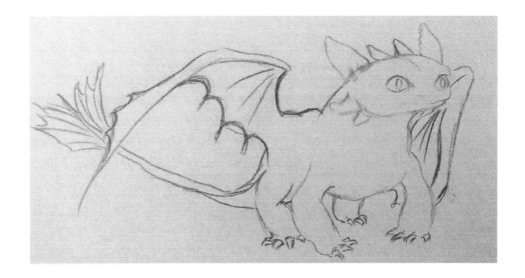

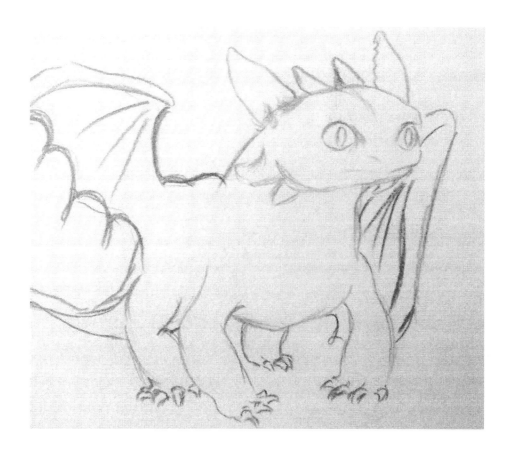

This is the most important part of your drawing because you are forming the whole dragon body, including wings and tail. Add some details on the wings and the tail end and draw claws.

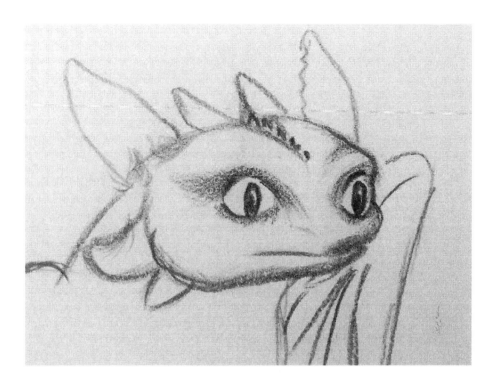

Now, start shading the head. Use more pressure on the pencil when adding eye shadows. Also, draw some spikes on the top of the head and bold them.

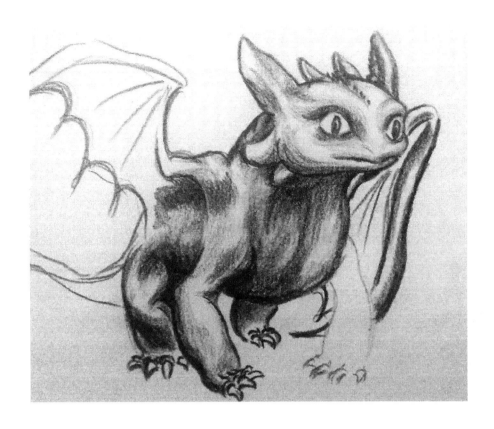

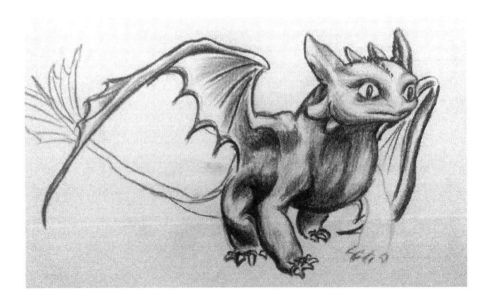

In this step start shading the body of the dragon including wings and legs. Vary with your pencil to get different degrees of tonal value.

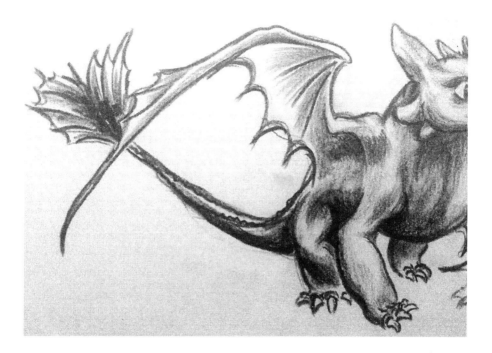

Then, you can add some shadows to the tail. This is pretty rough, so you can add some spikes and use more pressure on your pencil.

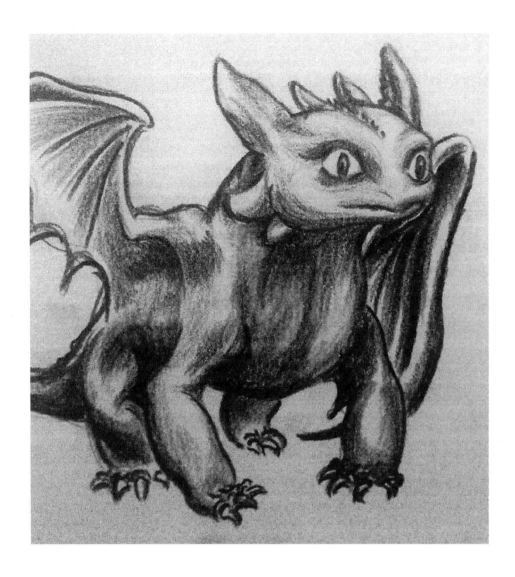

Finish up shading with the front left leg and left wing. Make sure that shadows are proportional and try not to lose the main structure of the dragon.

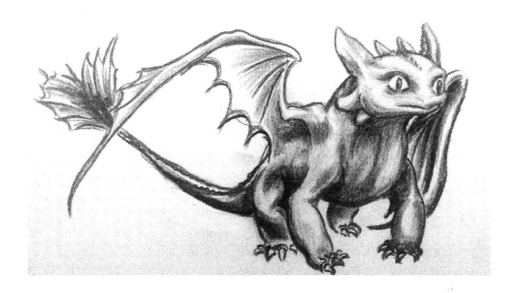

In the end, if you followed all steps, this is how your dragon should look about. Remember, your interpretation of dragon may be different, so use this steps as guidelines, not rules.

Conclusion

We sincerely hope that you like the book and that it will inspire you to start drawing dragons. But, keep in mind that you do not have to follow our rules when it comes to these characters – you can do whatever you like. You are free to open up your mind and create new characters. Think of their background story; imagine what powers they have and whether they're good or evil. All of this is totally up to you.

Still, use this book as guidance to drawing beautiful drawings of the characters. Using these step by step guides as a reference, you will save your time and make the drawings look amazing, thus staying enthusiastic about this kind of art.

Without any doubt, drawing dragon characters is a huge fun. It relaxes your mind and makes you forget about everyday worries. However, it can be much funnier if you do it together with someone else. If you have children, you can teach them how to draw, following the principles found in this book.

Learning how to draw interesting characters will do a lot of good for your kids. First of all, it will win the battle against boredom. Your kids will spend more time drawing than watching TV and playing computer games. The second reason is that drawing is a practice that is proven to have benefits on child's intelligence.

Not only can you turn your child into an artist, you can also help them become more creativity. Creativity means looking at things in unusual ways, which is the basic of intelligence. If you can find a simpler solution, you'll be able to solve the problem faster. Because of this, drawing can mean a lot to your children, despite seeming as just a way of fun.

The final reason is that drawing your kids' favorite movie characters will create a stronger bond with them. You are guaranteed to have fun, which your children will appreciate. Spending quality time means creating memories for the lifetime.

Of course, you can draw dragons on your own as well, but you can also include your colleagues and friends. Therapeutical benefits of drawing

are awesome. It frees your mind, allowing it to be creative. It can also provide you with a better understanding of your emotions.

You can use your drawings to see how you feel at the moment. Keep all of your drawings so you could compare the emotional states that you were in at the moment of creating them. If your dragons are cute and funny, that means that you had a good time drawing them. However, if they look grim and dangerous, it shows that the period in which you draw those drawings wasn't the best time of your life.

For all of these reasons, you should start drawing dragons immediately and recommend this book to your friends and family!

Thank you!

Thank you for choosing our book, we hope you found it interesting and helpful.

If you liked the book, please give us a favor to write your review.

We would really appreciate this!

If you would like to have a bonus – **FREE BOOK**, please send the screenshot of your review to this e-mail: **kelly.artbooks@gmail.com** and we will send you a **FREE BOOK** in PDF as a **GIFT!****

Hope to see you in our future books and good luck in your drawing experience!

**** in the e-mail subject please mention the name of the book you reviewed and the author.**